Art**Basics**

AN ILLUSTRATED GLOSSARY AND TIMELINE

WADSWORTH
CENGAGE Learning

Australia • Brazil • Japan • Korea • Mexico • Singapore • Spain • United Kingdom • United States

WADSWORTH
CENGAGE Learning

ArtBasics:
An Illustrated Glossary and Timeline

Publisher: Clark Baxter

Executive Editor: David Tatom

Acquisitions Editor: John R. Swanson

Assistant Editor: Amy McGaughey

Editorial Assistant: Brianna Brinkley

Technology Project Manager:
 Melinda Newfarmer

Marketing Manager: Mark Orr

Marketing Assistant: Annabelle Yang

Advertising Project Manager: Vicky Wan

Project Manager, Editorial Production:
 Candace Chen

Print Buyer: Judy Inouye

Text: Julia Moore

Text & Cover Designer: Ron Gordon,
 The Oliphant Press

Photo Researcher: Cheri Throop

Copy Editor: Libby Larson

For product information and technology assistance, contact us at
Cengage Learning Customer & Sales Support, 1-800-354-9706
For permission to use material from this text or product,
submit all requests online at **www.cengage.com/permissions**
Further permissions questions can be e-mailed to
permissionrequest@cengage.com

ISBN-13: 978-0-534-64101-6

ISBN-10: 0-534-64101-6

Wadsworth Cengage Learning
20 Channel Center Street
Boston, MA 02210
USA

Cengage Learning is a leading provider of customized learning solutions with office locations around the globe, including Singapore, the United Kingdom, Australia, Mexico, Brazil, and Japan. Locate your local office at **www.cengage.com/global**

Cengage Learning products are represented in Canada by Nelson Education, Ltd.

To learn more about Wadsworth, visit **www.cengage.com/wadsworth**

Purchase any of our products at your local college store or at our preferred online store **www.cengagebrain.com**

Printed in the United States of America
7 8 9 10 13 12 11 10

Contents

What Is Art, and What Is Not Art? 4
Discussion and description are more appropriate than definition.

What Is an Artwork? 5
Does it have to be a painting or sculpture to be an artwork? The answer is no.

Why Is Art Made, and What Makes It Valuable? 7
Artists and those who sponsor them have purposes for making art that range from pragmatic and public to playful and private. Society assigns the value.

 Artists and patrons 7
 Purposes 8
 Values 9

What Are We Looking At? 10
"Reading" works of art requires a new vocabulary.

 Subject 10
 Visual elements 11
 Medium 16
 Form 16
 Composition 16
 Style 18
 Content 18

What Is Art Made Of, and How? 19
Artworks and architecture are physical objects created with various means (materials) and in different ways (techniques).

 Drawing 20
 Painting 20
 Graphic arts 22
 Photography 24
 Sculpture 25
 Architecture 26

What Are We Looking For? 29
In studying works of art, the questions (besides how and why) are what, when, where, and who.

 Documentary evidence 29
 Evidence of the object 29

Where Do You Find Art? 30
And once you find it, what are the most favorable conditions for experiencing it?

Studying Art and Learning about Art 31
Art can be approached by many paths.

 Art appreciation and art history 31
 Art history methodologies 31

Artistic Periods in the Western Tradition opposite page 32

Timeline of Major Events in Western Cultures inside back cover

ArtBasics

Whether you are taking a course in art appreciation, art history or the humanities, or are studying art and design, ArtBasics will orient you to art in both general and specific ways. Read it to learn what to look for when you find yourself face-to-face with a work of art, and return to it when you need to review or reinforce your grasp of art's specialized concepts and vocabulary.

What Is Art, and What Is Not Art?

Discussion and description are more appropriate than definition.

We live at a time when artists—and even some art historians—are celebrities, when museums are top tourist attractions, when works of art change hands for huge sums of money, and when being knowledgeable about art is perceived to be a social advantage. In fact, if we include museums, galleries, teaching institutions, auction houses, insurance companies, tourism, art books, and other printed and digital reproductions, art is an enormous industry.

The logical first question here is, What is art? The only acceptable response to this question is that there is no single answer or definition. We can describe qualities that works of art possess, and we can draw boundaries to separate what we recognize as art from what we exclude as not-art, but we should not expect consensus on art's qualities and certainly not on where the boundary lines belong.

In the context of this brief look at art basics, the word *art* refers to physical objects made to be experienced visually and spatially: things drawn, painted, sculpted, crafted, or designed and built. Yes, the performing arts of dance and theater are visual and spatial, and film is nothing if not visual. But for our purposes, art is what most of us think of as art and what we learn as students of art or art history.

One indisputable qualification is that a work of art is *intentionally* made by human hands (sometimes with the aid of machines) and was *imagined* before it was made. This means that a sublimely beautiful sunset is not a work of art, but that a painting of the same sunset is. What if the painting is a bad painting? Is it still a work of art? As with all things made by humans, *measures of quality* apply to works of art. These include

> technical skill and craftsmanship
> originality and depth of the idea behind the work of art
> degree to which the finished work satisfies its intention or its purpose
> level of aesthetic achievement

Technical skill and craftsmanship can be taught, and we can see and appreciate them in works of art. It is also possible to assess *originality of thought and depth of ideas*, and the more art you are familiar with, the more readily you can recognize genuine originality. The same is true about measuring the *degree to which a work of art satisfies the artistic intention or purpose set for it*. The more you know about why it was made and what purposes it was supposed to serve, the better prepared you are to judge whether that work of art achieves its goals. It is the *aesthetic qualities* that are subjectively perceived and so are more debatable.

> NOTE: *The word* art *descends from the Latin word* ars, *meaning any skill that requires training to learn it and much practice to do it well. To the Romans,* ars *applied to warfare, oratory, medicine, and gymnastics just as comfortably as it did to sculpture and painting.*

Aesthetics (or esthetics) is a branch of philosophy that deals with the concept of

beauty. Aesthetics is not a science, and its measurement is imprecise. What is valued as beautiful in one culture or society is not necessarily beautiful in another. And "beautiful" can change over time in the same culture. Taste accounts for the change.

We usually associate *taste* with fads: temporary or specialized preferences and enthusiasms. But taste has another dimension, one that we could describe as an *innate and steady capacity to discern quality and beauty* that is not transient and is present throughout time in many manifestations of culture. When an individual adds knowledge of a field to that innate sense of taste, he or she has the potential to be a **connoisseur**, someone who can tell the difference between the authentic and the imitative and is finely tuned to shades of quality.

We return to the painting of the sunset and the question, Is there such a thing as a bad work of art? Obviously, the answer is yes. By the four measures we have just considered, most art falls far short of being great, and individual artists—even the most gifted and accomplished ones—are not infallibly consistent. The greatest works of art, however, have inspired wonder and excitement for generations. They rise to the top, and, together with others of similarly high quality, are recognized as a **canon**—a collections of works by which other artworks are measured and judged. As a student, you may be introduced to more than one canon, depending on which tradition you are learning—Western, Asian, Mesoamerican, or other, more circumscribed areas. You will also encounter creations that will challenge your critical skills and perhaps force you to find your own criteria for deciding whether what you are looking at is great, good, ordinary, poor—or even whether it should be considered a work of art.

What Is an Artwork?

Does it have to be a painting or sculpture to be an artwork? The answer is no.

Here are some things to think about.

> A number of societies have no words for art or art object.
> Objects made for religious or utilitarian purposes (and not thought of as art) in one culture may be treasured as great art by another culture.
> In Western cultures, the aesthetic value of utilitarian objects fluctuates and is more valued in some periods than in others.
> Some artists declare certain "found" objects to be art because they believe that being an artist empowers them to confer art status on just about anything.
> The best-attended special exhibition ever mounted by the Solomon R. Guggenheim Museum in New York City was its 1998 show, The Art of the Motorcycle, which featured actual bikes.

A favorite way that Western cultures deal with disorder—if not chaos—is to define things. If we can find a definition for something, we believe it exists. Likewise, we are prone to categorizing and assigning value rankings. Since ancient Greek times, more than two thousand years ago, the arts have been defined, classified, and ranked in order of their value to society. Over time, these definitions, categories, and rankings have changed. They are changing still. In fact, we live at a moment when old classifications and rankings are breaking down so fast that we have to acknowledge the disarray and rethink the traditional definitions.

Most art history courses and textbooks that emphasize the Western tradition concentrate on painting, drawing, the graphic arts, sculpture, and architecture—the

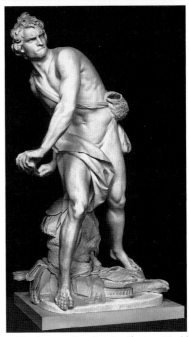

1. Gianlorenzo Bernini. *David.* 1623. Marble. Galleria Borghese, Rome. © Scala/Art Resource, New York.

Bernini's dynamic portrayal of David at the crucial instant before he flings a stone at the (unseen) giant Goliath is a quintessential example of fine art as Renaissance artists defined it—and as artists, critics, curators, and art historians understood it until now.

2. Honami Koetsu. *Boat Bridge*, a writing box. Japan. Edo period, early 17th century. Lacquered wood, with sprinkled gold and inlay. Tokyo National Museum, Japan. Kyoryokukai.

This box, made of lacquer by a great Japanese calligrapher and master of lacquerware (a technique developed and favored in East Asia), was made to be used and also appreciatively contemplated for its aesthetic pleasures. It is an example of Asian art that is decorative, utilitarian, and supremely beautiful.

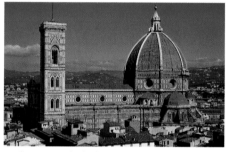

3. Florence Cathedral. Begun 1296 and consecrated in 1436, after enlargement from the original design and construction of the dome. © Alinari/Art Resource, New York.

Several architects and artists were in charge of building the Cathedral (or Duomo, in Italian) over the 140 years it took to complete it. The first, Arnolfo di Cambio, produced a design that was typical of late medieval Italian architecture. The last, Filippo Brunelleschi, was one of the great sculptors and architects of the early Italian Renaissance. He was the architect/engineer of the great dome, which was constructed beginning in 1420.

traditional fine arts. Photography began to be recognized as worthy of inclusion in the canon of art history beginning in the 1960s. Now we are seeing a rapid acceleration of inclusiveness, not only in textbooks but also in museum exhibitions and gallery shows.

In categorizing areas of human endeavor and thought, the ancient Greeks identified seven subjects as **liberal arts**: grammar, rhetoric, logic, geometry, arithmetic, astronomy, and music. The first three are language-based, the last four are based in mathematics. All through the European Middle Ages, these same liberal arts categories prevailed. In this scheme, painting and sculpture were ranked below the liberal arts and were regarded as practical activities—the work of artisans. Both were learned in the highly regulated medieval **guild system** that controlled the manufacture and distribution of all trade items and religious art.

Only in the Renaissance did artists begin to argue that painting is a liberal art. Leonardo da Vinci took the debatable position that painting speaks to the sense of vision, which, he claimed, is a more refined human sensibility than the aural sense (sound), on which the language-based arts rely. Toward the end of the sixteenth century, while painting and sculpture were gaining acceptance as liberal arts (and partly to capitalize on their newly elevated status), artists formed the first **art academies** (art schools) with the intention of creating intellectual and creative bases for the study of art, chiefly drawing and sculpture. For three hundred years, academies ruled artistic training and taste in Europe, and painting and sculpture came to be known as **fine arts**. Artists in the nineteenth century eventually rejected the academy system, but the term *fine arts* lived on.

Why is it important to know a little about the evolution of these categories? The answer is that since the Renaissance, when fine art was defined, writers, critics, and artists themselves have made a distinction between fine art (also sometimes called **high art**) and **decorative art** (**applied art**, **craft**, or **minor arts**). This distinction—some would say discrimination—has viewed furnishings and furniture as merely mechanical, lacking a theoretical underpinning, and not as intrinsically unique creations. Works of glass, pottery and porcelain, metal, wood, fiber, enamel, leather, and newer materials—regardless of their artistic quality—were not taken as seriously as objects of fine art.

Today, the high/low distinction seems less relevant than ever before. (For one thing, a number of major world cultures—including Chinese, Japanese, and Korean—never have made a distinction based on utility.) In the West, the debate continues as to whether something is art or craft, but in fact the decorative arts are increasingly incorporated in the disciplines of art history. The history of **architecture**, an applied art based in geometry and engineering and having major aesthetic and social dimensions, is taught with the history of art.

Why Is Art Made, and What Makes It Valuable?

Artists and those who sponsor them have purposes for making art that range from pragmatic and public to playful and private. Society assigns the value.

Almost invariably, artists are sponsored by persons or institutions who **commission** (order) and pay them—or reward or honor them in some important ways—for their skills and talents, their time, and the costs of materials. Such people and institutions are **patrons**. Over the long history of art, patrons have been

Artists and patrons

> the community
> the state
> religious institutions
> secular institutions
> royalty and aristocracy
> wealthy individuals
> corporations and businesses

The earliest paintings we have, painted on the walls of caves in southern Europe some 30,000 years ago, were surely sponsored by a *community* in the sense that the artists must have been exempt from some communal duties and honored for their ability to conjure believable creatures. Communities still commission works of art—public sculpture and murals, for example—and sponsor art-centered activities such as art fairs.

States (in the sense of nation-states) have been active art sponsors throughout history. The city-state of Athens in ancient Greece supported not only great architecture, but also some of the greatest sculpture ever carved or modeled. So did Rome when it was in power.

Organized *religions* have sponsored art directly and indirectly. In all cultures and religions, wealthy patrons, many of them *royal or aristocratic families*, have supported artists and architects in the building and decoration of places of worship, usually by giving to the religious institutions that engaged the artists. Egyptian temples came about this way. In Europe, certain powerful clerics directly commissioned works of art from renowned artists and architects. A famous example of this is Michelangelo's decoration of *The Last Judgment* on an end wall of the Sistine Chapel at the Vatican in Rome, which Pope Paul III commissioned.

> NOTE: Royalty *refers to ruling families in monarchies, kingdoms, and empires. Nobility is used to mean titled persons (such as dukes and duchesses) and their descendents, as well as people whom royalty has granted special social status. Members of nobility usually own inherited land. Aristocracy is an encompassing term that describes the highest social stratum of a society and includes royalty and nobility.*

Kings and queens, emperors and empresses, and others in power have used their wealth to command as well as commission creation of some of the world's greatest art. When, in the early Renaissance, wealth spread to *merchants, traders, and manufacturers*—and then to the *professional class*—private collectors developed as an important source of patronage and eventually became influential **donors** to museums. And when art was seen as having great investment potential, along with the benefits of elevating an institution's civic and social status, businesses and corporations became art patrons.

We associate art with museums, and for good reasons. Museums are where much art has ended up. These institutions protect and conserve art, and they organize and explain it. What they cannot do is reproduce the original physical and social contexts of the art they display.

Until comparatively recently, artists did not think about whether their works would be seen in museums. (Museums open to the public have existed only since the early nineteenth century.) Art was and is made for many purposes. Because it is a nonverbal medium, art can speak to anyone, including those who cannot read written languages.

Among the purposes to which art has been put are to

> give form to religious impulse and belief
> demonstrate power, authority, wealth, and status
> commemorate
> influence opinion (propaganda)
> teach lessons and tell stories
> satisfy a need of the artist
> sell as a means of livelihood

More art has been made in the service of *religion* than for any other purpose. From temples and churches to precious objects used in rites and worship, from altarpieces to painted and carved interior and exterior walls, from unsophisticated provincial carvings of holy personages to the most refined miniature paintings that illustrate sacred books, artists and architects—because of their patrons—have given form to religious belief.

The impulses behind both religious and secular art can also be worldly. An intrinsically valuable object—one made of precious and costly materials—proclaims the *wealth* (and thus usually *status* and *power*) of the patron. Large building programs are very effective at impressing followers and foes alike. The pyramids of ancient Egypt are powerful witnesses to the dual purpose of ensuring a safe and comfortable afterlife for the king and proclaiming the power of his dynastic rule to his subjects. Today, corporations and foundations are sponsoring major art exhibitions; it is an investment in public relations and goodwill.

The line between commemorating and intending to influence opinion is a fine one. Art can *commemorate* an event or a person without injecting opinion. Figure 1, which shows the future second king of the Israelites, David, poised to hurl a stone at the giant Goliath, illustrates an Old Testament story and *commemorates* David's brave act. Art becomes *propaganda* when it attempts to persuade people of a point of view that may not be just. A famous example of a painting that is propagandistic is figure 5, Diego Velázquez's *Surrender of Breda*.

Images are eloquent teachers and storytellers. Art has been used to remind people of things known from oral traditions of history, legend, and mythology, and sometimes from sermons and teachings. Art gives form to these lessons and stories. It has the power to move the beholder in ways that the written and oral word do not. Figure 12, on page 12, is an electrifying depiction of a familiar moment from the New Testament, when an angel tells the shepherds that the promised son of God has just been born.

Sometimes—and this is a particularly modern phenomenon—the purpose of a work of art is personal to the artist, something made simply because the artist needed to do it.

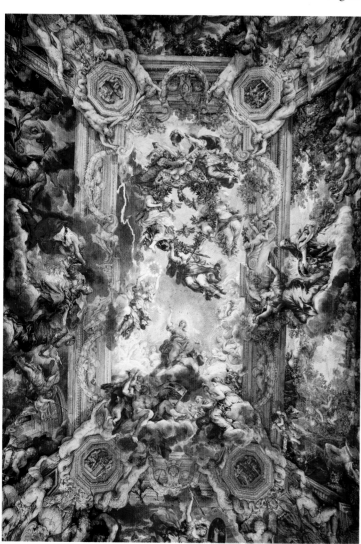

4. Pietro da Cortona. *Triumph of the Barberini.* Ceiling fresco in the Gran Salone, Palazzo Barberini, Rome, Italy. 1633–39. © Scala/Art Resource, New York.

The ceiling of a large room is a perfect field for a painting that can awe viewers. This ceiling painting was commissioned for one of the largest rooms in the Barberini family palace in Rome by a member of the Barberini family—the reigning pope at the time, Pope Urban VII. The open heavens suggest that the whole family is on good terms with God. Divine Providence, in a bath of yellow light, is signaling the figure of Immortality (dressed in red) to grant the entire Barberini family eternal life. The scale and technical proficiency of the painting speak of the wealth, confidence, and power of its patron.

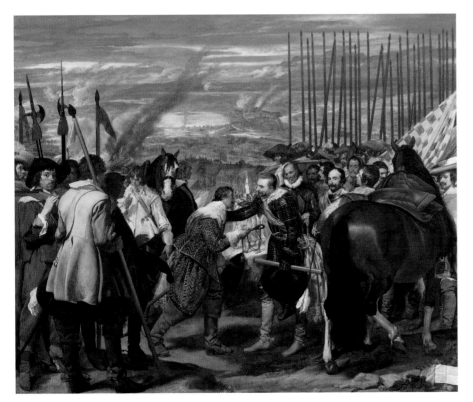

5. Diego Velázquez. *Surrender of Breda*. 1634–35. Oil on canvas. Museo del Prado, Madrid, Spain. © Bridgeman/Giraudon/Art Resource, New York.

Velázquez was a renowned Spanish painter in the court of King Philip IV. He painted this very large canvas to put a good face on a bitter national event: Spain's vanquishment of an insurrection by the Dutch against Spanish rule in the northern Netherlands. Surrender of Breda *depicts the mayor of the Dutch town surrendering the city keys to the victorious Spanish general, who pats the defeated official on the shoulder. The Spanish troops behind the general are arranged to look orderly, fresh, and even dapper in contrast to the raggle-taggle Dutch fighters—another propagandistic touch.*

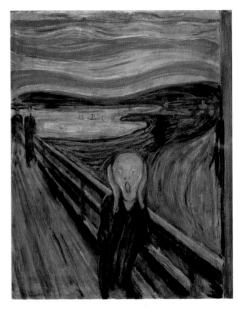

6. Edvard Munch. *The Cry*. 1893. Oil, pastel, and casein on cardboard. National Gallery, Oslo. Scala copyright © 2001, The Munch Museum/The Munch-Ellingsen Group/ARS.

We know from his writings that the artist Edvard Munch was obsessed with the futility of trying to control the forces of nature, love, and death. He experienced that powerlessness acutely and personally. This painting, originally titled Despair, *was surely an expression of torment and feelings of isolation, what Munch called "modern psychic life," and may have been painted to try to purge his anguish.*

In an age like ours, where private patrons and benefactors are rare, much art is made to sell. It is intended to be the artist's livelihood. Inevitably, artists who rely on collectors to buy what they create are aware of tastes and collecting trends. They have to decide whether to follow the current vogue or their own vision, or try to do both. There is nothing fundamentally new about this situation, however. The complex, push-pull relationship between artist and sponsor is almost as old as art.

The factors that determine the value of individual works of art parallel those operating in other areas of society. The *intrinsic value* of the materials is a straightforward measure of something's worth. *Rarity* is another factor. *Quality* is a very important determinant of value. As we have seen, *taste* affects value, and tastes change over time. What is certain is that art is perceived as a precious human creation, one worth preserving and paying for.

Values

What Are We Looking At?

Subject

7. Sandro Botticelli. *The Birth of Venus.* c. 1485. Tempera on canvas. Galleria degli Uffizi, Florence, Italy. © Summerfield Press, Ltd.

If the title didn't tell us that the subject is the birth of Venus, most of us would be clueless about what we are looking at. (In the artist's day, any literate man or woman could identify the figures, explain the scene, and interpret its meaning.)

Why is Venus fully grown and riding on an oversize shell if this is her birth scene? To know why, you must know something about Greek and Roman mythology. Venus is the Roman goddess of love and beauty. Mythology holds that she was born out of the sea foam and floated to shore on a scallop shell. Who are the two flying figures on the left? The one with wings is Zephyr, personification of the gentle west wind of springtime. To leave no doubt about Zephyr's identity, Botticelli painted his breath as a pale streak that blows Venus toward the shore. The flying female figure is usually identified as a wind goddess but could be the nymph Chloris, whom Zephyr took as his wife; thus, she became Flora, goddess of flowers. The pink roses that surround Zephyr and his companion could be symbols of Flora, but they are also one of a number of Venus's attributes. On the right is Pomona, goddess of fruit trees, which are seen as an orchard backdrop.

"Reading" works of art requires a new vocabulary.

We have to learn to "read" works of art on their own terms and in their own language. Experiencing a work of art is fundamentally different from reading a poem, or watching a dance performance, or listening to music. We take in these art forms over a period of time, as they are being performed or as we are reading them—a word at a time or a sound at a time or a movement at a time. Looking at a work of art calls for *simultaneous perception* of what we see, of what it represents, and what it all means. This is because *we encounter most works of art as complete physical objects, all at once.*

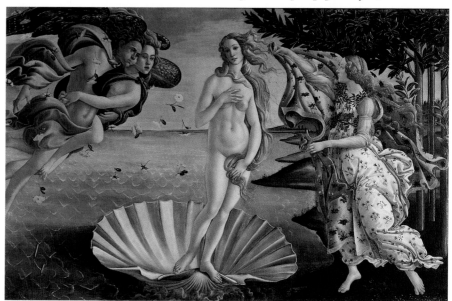

Works of art have been made because artists have things to say, often urgently. The "language" artists use is a visual one, with specialized "grammatical" elements and conventions that are comparable to parts of speech—the basic components of written and spoken language such as nouns, pronouns, verbs, and adjectives—and to syntax, which is the way linguistic elements are put together. In works of art, the main "parts of speech" are

> subject
> visual elements, called formal elements
> medium
> form

The visual "syntax" includes

> composition
> style
> content

Subject is what an artwork is about and a prime reason it was created. The subject, or **subject matter**, of a work of art is the equivalent of the topic of an essay or the plot of a novel. It can be *recognizable* from human experience, but it does not have to be. Recognizable subjects are things like landscapes, human figures, still lifes, historical events, religious scenes, moments of everyday life, mythological stories, even decorative motifs, such as flowers. The subject matter of figure 7 is a scene from Greek mythology.

The study of subject matter in art is called **iconography**. An uncomplicated example of iconography would be a landscape scene, particularly if the artist identified the place in the name of the artwork. A more complex example is the iconography of figure 7, *The Birth of Venus*, painted about 1486 by the Italian Renaissance artist Sandro Botticelli. To know the subject of this painting, you have to do more than describe the scene. You need to know who the figures are and what they represent—individually and as an ensemble. In order to do that, you need to employ a subspecialty of iconography, iconology, which is the study of **symbols**.

The Birth of Venus offers the opportunity to use three "tools" of iconology: symbol, personification, and attribute. A **symbol** can have a literal meaning and a secondary or conventional meaning, in which it stands for something else. By drawing on a knowledge of Roman mythology, we know that besides love and beauty, Venus symbolizes spring, a secondary meaning. More by association with fruit trees and orchards than because of explicit mythology, Pomona symbolizes summer. Zephyr is the **personification** of the west winds that accompany spring and, in this case, help move spring toward summer. The **attribute** of roses refers to Venus and perhaps to Flora also. In art, as with religious subject matter, attributes are often shown with a figure to identify the subject.

> NOTE: *In the barest sense, everything depicted is symbolic. For example, a picture of a carnation is simply a painting of a flower. However, a portrait of a European man or woman holding a carnation probably carries a secondary meaning: The flower signifies that the person is engaged to be married. Iconology studies this level of symbolism.*

Subject matter can also be ideas, emotions, or states of mind. Such subjects can be expressed simply by lines, shapes, and colors that have *no recognizable* forms or specifically identifiable objects. Figure 8, a landmark painting of the mid-twentieth century by American painter Jackson Pollock, is such a painting. The title gives us no information about what the artist's subject was. From documentary evidence about Pollock, we know that he was seeing a psychoanalyst at the time he painted *One* and that he believed that the unconscious mind could be revealed through the act of painting. But what we see is a tangled, pulsating layering of lines that each of us can interpret in our own way.

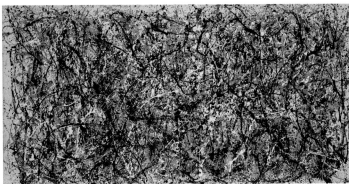

8. Jackson Pollock. *One (Number 31, 1950)*. Oil and enamel paint on canvas. The Museum of Modern Art, New York. Sidney and Harriet Janis Collection Fund by exchange. Copyright © 2003 The Museum of Modern Art/Art Resource, New York. Copyright © 2003 The Pollock-Krasner Foundation/Artists Rights Society (ARS), New York.

The next part of speech we call **formal elements**, that is, what we see when we look at artworks.

> line
> shape
> mass and volume
> color
> texture
> space
> scale and proportion

Visual elements

LINE
Of all the formal elements, *line* is the most familiar to us—and the most basic to the artist. Line is the mark that is left when some kind of dark substance is moved, or drawn, across a lighter-colored surface, or the reverse, light line on dark surface. The first images we make as children are scribbled lines, followed in time by things like stick figures and the sun—a circle with lines radiating from it.

9. Actual and implied lines

10. Examples of regular lines

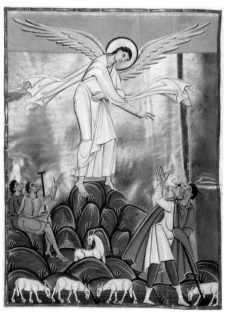

11. Two irregular lines

It may seem unnecessary to describe what seems obvious about line. But it is worthwhile, because as you look more carefully at the way an artist constructs an image, you will find that the handling of line is neither simple nor simplistic.

Actual and implied line

In *The Birth of Venus*, figure 7, much of the line is continuous and **actual**. But line can also be simply **implied**, as it is in the groupings of figures: a diagonal on the upper left (Zephyr and the wind goddess) and an opposing one on the right (Pomona, leaning forward), with a vertical between them (Venus). It is the human eye/mind process that makes directional lines out of groupings such as these. *The Birth of Venus* depends heavily on line to depict the subject. The shapes and features of the figures, both nude and clothed, are defined by line. So are the giant shell, the places where the sea meets the sky and the land, the leafy fruit trees, the sea's wavelets, even the breezes Zephyr blows to nudge Venus toward shore. This painting, like all of Botticelli's drawings and paintings, is described in the language of art as **linear**.

> NOTE: *Directions affect us differently, probably because we have kinetic associations from within our bodies. Horizontal is perceived as restful, like sleep or a body of water. We respond to vertical as a potentially active direction—think of the difference between lying down and standing up. Diagonal line suggests and is perceived as active motion, the direction of attack or speed—or of falling down, one of our most primal fears.*

Regular and irregular line

It is useful to be aware of whether line is *regular* or *irregular*. **Regular lines** are essentially straight or have rhythmic predictability. A curved line and a zigzag can be regular; so can a spiral or wavy line. The scallop shell in *The Birth of Venus*, figure 7, is formed of regular lines.

Irregular lines follow routes that are not balanced. Irregular line defines the edges of Pomona's garments and the wrap she extends to Venus.

Expressive line

Line has tremendous potential to express and arouse emotion, and, in general, regular lines are less **expressive** than irregular lines. When we say a line is "agitated," "lyrical," "manic," or "serene," we are really talking about the effect it has on us, which is an entirely valid way to respond.

Functions of line

Defines edges. When line is used to define edges, it creates shapes. We call such lines *contour lines*. The figure of Venus is a perfect example of this. Botticelli created her out of empty space by *outlining* her edges, then filling in the outline contours with color.

> NOTE: *Sculptors think in terms of contour as well, but differently because most sculpture has no fixed point of view. Its contours shift according to where we are positioned in relation to it.*

Suggests movement and direction. Line is also sometimes used to "draw" **movement**, and when the artist does that—most often in drawings and sketches—you may feel some of the *gestural energy* the artist felt at the moment he or she laid down the line.

An important organizing use of line is **axis** (plural is **axes**). Axes are imaginary lines of **direction** around which a figure or scene is arranged. The axes in *The Birth of Venus* are sketched at the top of the page opposite.

Creates illusion of depth and texture. Artists manipulate line in various ways to give the illusion of depth, shadows, and tactile surface. Most methods involve series of short, parallel lines of varying closeness and thickness, and of these methods, **hatching** is the most common.

12. *The Annunciation to the Shepherds.* Folio in the *Lectionary of Henry II,* from Reichenau, Germany. 1002–1014. Bayerische Staatsbibliothek, Munich, Germany. Tempera on vellum. Bayerische Staatsbibliothek, Munich.

In this illustration from a medieval book of readings, the lines are active and tense. They are expressive of intense feeling surrounding the highly charged moment when an angel appeared to shepherds to announce that Jesus had just been born. A good example of implied line that is psychic, not formal, is that created by the gaze between the angel and the shepherd on the right. We feel it strongly without any explicit visual cue.

SHAPE

Another formal element, **shape** is usually regarded as a two-dimensional element. A shape is delineated from its surroundings in some way, either explicitly with outlines or implied. Much of the terminology of shape is familiar from geometry: circle, square, rectangle, oval, triangle, hexagon, octagon, trapezoid, and lozenge. Irregular shapes, described as "biomorphic," are fluid and curvy.

MASS AND VOLUME

The terms *mass* and *volume* tend to be used interchangeably in speaking about three-dimensional arts such as sculpture and architecture. **Mass** is a solid form that takes up real space. **Volume** takes up space, but may contain space as well, as a building does. Mass is always solid; volume can be both solid and hollow.

COLOR

Color is a formal element that is essential to painting, the decorative arts, and design but is not fundamental to sculpture or architecture. The science of color optics is fairly advanced physics. Fortunately, you need to know only the most basic optical principles to appreciate color as one of the formal elements.

Color exists because of light and only when there is light. The sun's light—white light—is part of the vast spectrum of energy the sun gives off as waves. We perceive this part as the colors in rainbows. Light waves bounce off objects and pass through the retina of the eye to the brain, which interprets the waves as colors. The properties of color that are most basic to making and appreciating art are

> hue
> value
> intensity or saturation

Hue

When we use the word *color*, we are speaking of **hue**. Crayolas® are wax sticks of various hues. The **primary hues**—red, yellow, and blue—can be combined to form the **secondary hues** of orange (red + yellow), green (yellow + blue), and violet (red + blue).

Each of the primary colors has a **complementary color**, which is made by mixing the other two primaries. Thus, the complementary hue of red is green; violet is the complementary of yellow; and orange is complementary to blue.

The **warm hues** of red, orange, and yellow seem to come forward in relation to other hues and actually stimulate the sensation of warmth by association with fire and sun. **Cool hues** (blue, green, and violet) appear to recede from the viewer and have a cooling effect, probably from associations with shade, water, and greenery.

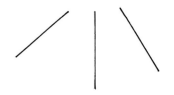

13. Diagram of axes in *The Birth of Venus*, figure 7.

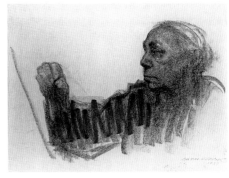

14. Käthe Kollwitz. *Self-Portrait*. 1924. Charcoal on paper. National Gallery of Art, Washington, D.C. Rosenwald Collection. National Gallery of Art, Washington, DC, Rosenwald Collection. Copyright © 2003 Artists Rights Society (ARS) New York/VG Bild-Kunst, Bonn, Germany.

The self-portrait by the early twentieth-century German artist Käthe Kollwitz, drawn and filled with broad strokes of charcoal, is an un usually pure example of gestural line. The irregular, jagged "spring" Kollwitz drew from her shoulder to her wrist suggests an urgent, almost overwhelming energy she felt impelling her in the act of drawing.

15. Hatching, cross-hatching, and contour hatching

16. Shapes: circle, square, triangle, hexagon, lozenge, and two biomorphic shapes

17. A sphere is the mass equivalent of the circle shape, the cube of the square shape, the pyramid of the unilateral triangle.

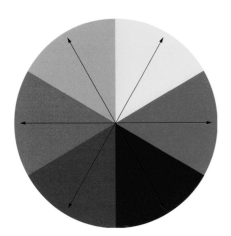

18. On this traditional color wheel, the primary colors—red, yellow, and blue—are found across from their complementaries: green, violet, and orange.

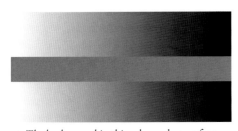

19. The background in this value scale runs from black to white. The narrow bar that runs through the middle is the same tone, a medium value, although it looks lighter against dark and darker against light.

20. In this scale, the hue is the same and the value is unchanged. The property of intensity is seen in the difference between the saturated hue and the grayed versions of that hue.

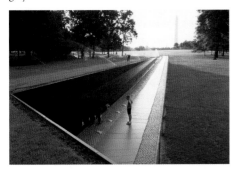

21. Maya Ying Lin. *Vietnam Veterans Memorial*, Washington, D.C., 1982. Polished black granite, with incised lettering. Copyright ©Frank Fournier/ Contact Press Images/Picture Quest.

Maya Ying Lin's granite wall is smooth, cool, and hard but also pitted by the chiseled-in names of the war's more than 58,000 dead Americans. Touch is not discouraged at the site, and it adds immensely to the experience of this great monument.

22. (right) Audrey Flack. *Marilyn*. 1977. Oil over acrylic on canvas. Collection of the University of Arizona Museum, Tucson. Museum purchase with funds provided by the Edward J. Gallagher, Jr. Memorial Fund (82.35.1).

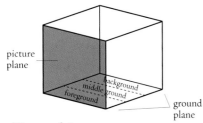

23. Diagram of picture space

Value

The degree of lightness or darkness in a color is its **value**. To state the obvious, dark green looks darker than light green. When a picture is reproduced in black and white, value is the only thing we see. In the colorless (achromatic) range between black and white, especially in prints and drawings, every tone is a value.

Intensity

The brightness or purity of a hue is called **intensity**, or sometimes **saturation** or **chroma**. Adding gray to a color lowers its intensity; so does mixing a hue with its complementary color.

TEXTURE

In the language of art, **texture** refers only to the visual or tactile surface characteristic of an object. But there are two categories: actual and simulated, or visual.

Actual texture. What you feel when you touch something: roughness, smoothness, hardness, and the like. Although we are discouraged from touching sculpture in most museums and galleries, texture is a major formal element of three-dimensional artworks.

Simulated texture. The appearance of texture, such as flower petals in a still life, or brocades of a fancy garment. Texture is often hinted at in painting or graphic arts, and the eye/mind fills in what the artists omitted or merely suggested.

When an artist makes an exact likeness of something in a realistic way, the result is **trompe l'oeil** (French for "fool the eye"). Simulated texture is one of the main formal elements used to achieve that effect.

Audrey Flack's *Marilyn* (figure 22) is a fine example of trompe l'oeil technique in the way it renders individual objects in the painting with convincing plausibility.

SPACE

The urge to impose order on space has engaged artists in the Western tradition for at least 5,000 years. (In other traditions, the logical representation of space matters less.) The challenge has centered on representing the three-dimensional world on

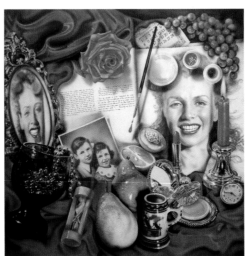

surfaces that are two-dimensional. Height and width are easy to reproduce, but depth is not. How does one show that one herd of buffalo is closer to the viewer than the other herd? What will make us believe that these figures occupy space? The progressive "conquest" of space is one of the few evolutionary patterns in Western art.

The two-dimensional surface on which artists paint or draw is called the **picture plane**. The imaginary area behind the actual flat "front" plane is the **picture space**. Imagine the space as a transparent cube. The side closest to you is the picture plane. The side of the cube resting on the ground is the **ground plane**. From front to back, the space is informally zoned **foreground**, **middle ground**, and **background**. Lines perpendicular to the picture plane along which objects recede into space are **orthogonals**.

Over time, artists have devised a number of pictorial strategies to create the **illusion of depth**, including some that appear to reach outward, toward us, from the picture plane. Here are some of them.

Vertical stacking, or vertical perspective. Here, objects that are to be interpreted as farther from the viewer are placed higher on the picture plane. The lowest zone

is for the closest objects. *Diagonal perspective* is when objects that are more distant are high on the picture plane and also aligned on a diagonal axis, which suggests continuous recession into the picture space.

Overlapping forms, and diminishing size and interval. Another comparatively simple device for showing spatial relationships is *overlapping*, in which receded objects are placed behind forward ones. Drawing on experience in real space, our minds interpret partially covered objects as being behind those not obscured by anything else.

We interpret size relationships in much the same way: Large is interpreted as closer than small. Forms of *diminishing size* arranged side by side, and with decreasing space between them, also appear to recede into the picture space.

Atmospheric perspective. The illusion of recession into space can be achieved by simulating the way we perceive the color and surface textures of distant objects. This is known as atmosphere, or aerial, perspective. In a landscape, for example, a faraway skyline or distant hills are paler than things that are close to us. Textures seem to flatten out, even disappear, in the distance. Painters imitate the effect by painting landscape elements or objects in the background in hues that are less intense than those in the foreground and middle ground.

Linear perspective. The most convincing pictorial device for creating the illusion of space was developed in the West in the fifteenth century. It is **linear perspective**, or **scientific perspective**. It is based on the perception that angles of planes (orthogonals) all recede to a point or points (**vanishing point/s**) on a horizontal axis in the distance (**horizon line**). The horizon line represents the viewer's eye level; sometimes it is an actual horizon line, but more often it is simply suggested.

Simultaneous perspective. Well before the principles of linear perspective were understood and established, artists combined various viewpoints in the same scene, in what we call **simultaneous perspective**. Audrey Flack's *Marilyn,* figure 22, which is a comparatively recent work, depicts objects from many different viewpoints. In fact, some of the painting's power comes from the disorienting effect of having to rapidly shift our perceptions as we sweep around its surface.

SCALE AND PROPORTION

Scale is about size but is applied to the size relationship of objects to each other, to their surroundings, and often to human size. For example, when we photograph a famous landmark, including people in the picture gives a more-or-less accurate idea of the size of the landmark. The people are the scale.

In much ancient art, **hierarchical scaling** was used to indicate the relative importance of persons, objects, or events: the larger, the more important, so to speak. Intentional **distortion of scale**, like simultaneous viewpoints, is used to provoke the viewer to look and think more carefully about what is being said by an artwork. Look carefully again at Flack's *Marilyn* and note how Flack used distorted scale to undermine "reality."

If scale is about the relative size of different things, **proportion** is about the ratio of parts to the whole. Not surprisingly, the human body is the basis of most standards for proportion. When we describe someone as having long arms, we are really saying that they are long in proportion to an ideal norm. In Western art, the "normal" body is a physically fit-looking male, and the ratio of its parts is the

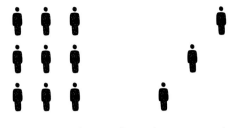

24. Schematic diagram of vertical perspective and diagonal perspective

25. Schematic diagram of overlapping forms and diminishing sizes and intervals

26. Limbourg Brothers. *May,* from *Les Trés Riches Heures du Duc du Berry.* 1416. Manuscript illumination, pigment in gum arabic on vellum. Musée Conde, Chantilly, France. © Réunion des Musées Nationaux/Art Resource, New York.

This scene from French court life at the beginning of the fifteenth century employs several spatial techniques to establish order. There are three zones in vertical perspective, occupying foreground (the procession), middle ground (the glade of trees), and background (the cluster of late medieval buildings). The hues of the stone walls and the roofs of these buildings are less intense than the comparable colors in the foreground (atmospheric perspective). Horses and figures overlap, indicating very clearly where each horse and rider is in relation to the others (overlapping perspective).

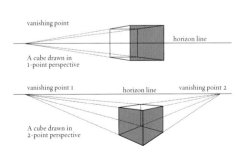

27. One-point and two-point perspective

norm, or **canon**. For example, in ancient Greek art, with the head as the basic unit, or **module**, the ideal height is 7 or 7½ heads tall. Canons vary with time and culture, however. Ancient Egyptians developed canons of proportions for drawing the human figure based on grids. (The proportions were different for men and women.) These grids changed over time but each one regulated the height ratios from the soles of feet to the hairline.

> NOTE: *In art, the word* canon *has two uses. One meaning, explained on page 5, refers to a body of artworks by which others artworks with common origins are judged. The second is described above: a body of standards, principles, or norms.*

Medium

Medium refers to the specific materials and tools an artist uses to create a work of art. (The plural is *media*, although some writers use ***mediums***, to distinguish between media as the press and its specific usage in art.) Medium can also be used to mean the general art form: painting, sculpture, graphic arts, ceramics, and the like. Media are treated at some length, beginning on page 19, under "What Is Art Made Of, and How?"

Form

Form, the fourth "part of speech," is the physical, material object that can be described in terms of formal elements. It is the sum of everything we have discussed above: line, shape, mass and volume, color, texture, and also composition, which is treated below. It is helpful to think of form purely as that which you see. In studying art and the history of art, you will find the words *form* and *content* in what you read and hear from professional artists and art historians. An artwork's form may be judged in formal terms and held up to standards of beauty (which are not fixed, by any means). But the form of an artwork is not by itself its meaning. Meaning is the territory of content, which is treated below with other elements of "syntax."

The three elements that parallel language syntax—the way the parts of speech are put together to make sense—are composition, style, and content.

Composition

The organization or arrangement of formal elements in a work of art is **composition**. Sometimes, composition is spoken of as design. The decisions an artist makes about where to position the formal elements—what to emphasize, what to minimize, and by which means to accomplish these things—are what compose a work of art. There are endless possibilities, as anyone who has approached a blank sheet of paper or canvas or slab of clay knows. Yet artists are subject to broad stylistic influences from the spirit of their times and the values of their cultures. With experience, we learn to recognize clues to the period/culture of art works in their compositions.

You can begin to analyze and even characterize compositions by looking for some fairly basic contrasting qualities, such as *repetition and contrast, symmetry and asymmetry,* and *open and closed composition.*

Repetition and contrast. As we look at this first characterization, we can ask, Do formal elements repeat in a way that diffuses—or even negates—a **focal point**? Might that be the artist's purpose? Is **repetition** a function of an overall patterning or decorative intent? Do repeated elements promote **unity** of the composition? Do they reinforce its message?

Contrast, or *variety*, is the opposite of repetition. Using figure 22, Audrey Flack's *Marilyn*, as an example of contrast, it is not difficult to see how contrast rules the composition of the formal elements of color, shape, texture, point of view (perspective), and scale.

Symmetry and asymmetry. In art, true **symmetry** is very rare. Also called **bilateral symmetry**, true symmetry is when both halves of a form or image are identical. Forms or shapes that look pretty much the same on both sides of an imaginary dividing line qualify as symmetrical when discussing composition. Symmetry gives stability and balance to a composition or design. The two figures forming the composition of the African sculpture from Mali shown in figure 29 show what can be called **symmetrical balance**. The piece has a symmetrical feeling, but the deviations from perfect symmetry are more interesting than two mirrored figures would be.

In composition, symmetry and **asymmetry** are matters of balance. **Asymmetrical balance** is a quality of all good compositions, when the weight of elements that are of different sizes, shapes, colors, and even textures strike a balance that is aesthetically satisfying.

An example of asymmetrical balance is figure 30, Mark Rothko's 1961 painting, *Blue, Orange, Red*. Although the larger blue field dominates the other two horizontal fields in size and thus creates asymmetry, the composition is not out of balance. Rothko offset size with intense color (the orange bar) and deep value (the smaller blue).

Closed and open composition. Besides being a composition that is asymmetrically balanced, Rothko's painting is a very clear example of **closed composition**. The entire picture is almost like a sealed box. Everything is contained within its borders, and nothing breaks loose. It seems self-contained in time and in space.

By contrast, an **open composition** shows only a portion of a larger whole—the artist's focus on a slice of the entire scene—both visually and temporally. An open composition seems to capture a moment rather than conveying timelessness. It also invites us to imagine what is not shown, but lies outside the artist's imposed boundaries. *The Peasant Wedding*, figure 31, a famous painting by Pieter Brueghel the Elder, the leading Flemish painter of his day, focuses on the table where the bride is seated (she is set apart by the black wall-hanging behind her). We are left to imagine the rest of the hall, even what is happening behind us.

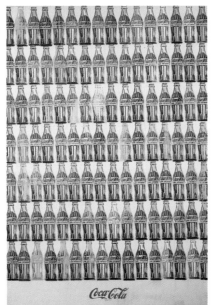

28. Andy Warhol. *Green Coca-Cola Bottles.* 1962. Oil on canvas. Collection Whitney Museum of American Art, New York. Copyright © 2003 Whitney Museum of American Art, New York.

Warhol's paintings and serigraphs (silk screen prints) of familiar commodities—Coke bottles and soup cans are the best known—were statements about mass culture and its celebration of things, especially lots of things. He put them in our faces, like mirrors. Warhol's commodification of culture extended to faces of celebrities, including those of Marilyn Monroe, Elizabeth Taylor, and Mao Tse-tung. In this painting, the only contrast is the trademarked signature of the product, an ironic redundancy.

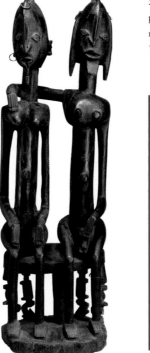

29. *Ancestral Couple.* Mali (Dogon). Wood. Metropolitan Museum of Art, New York. Photo copyright © 1982 Metropolitan Museum of Art, New York. All rights reserved.

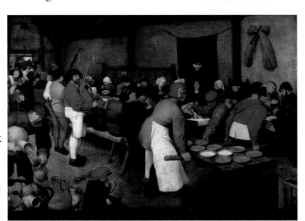

30. Mark Rothko. *Blue, Orange, Red.* 1961. Oil on canvas. Hirshhorn Museum and Sculpture Garden, Smithsonian Institution, Washington, D.C. Gift of the Hirshhorn Foundation, 1966. Copyright © 2005 Kate Rothko Prizel & Christopher Rothko/ Artists Rights Society (ARS), New York.

31. Pieter Brueghel the Elder. *The Peasant Wedding*, 1568. Oil on wood panel. Kunsthistorishes Museum, Vienna, Austria. © Erich Lessing/Art Resource, New York.

Style

Every work of art and architecture has a set of characteristics special to it. **Style** is this particular combination of characteristics and is one of art history's most important areas of inquiry and analysis. In a work of granite sculpture, one element of style will be the way the stone is cut and finished. In a painting, the quality of the line and the handling of paint are just two elements of its style. In architecture, style includes the massing of forms, overall proportions, and presence and placement of individual elements, to name a few.

Art historians group works of art and architecture according to their styles, partly to identify their origins (spoken of as **provenance**). Stylistic analysis was, in fact, the prevalent methodology of art history for many decades, based in the belief that classification can increase our understanding of almost anything. In fact, there are at least three recognized and very useful categories of style:

Period style. Assigns artworks with common stylistic elements to a period of time, usually within a specific culture (Archaic Greek) or cultures (Art Deco). Signed and documented works of art were rare before the Renaissance. A classic example of Early Italian Renaissance style is figure 33 (page 21), Masaccio's wall painting, *Holy Trinity.*

Regional style. Recognizes stylistic traits common to a geographical area, even over long periods of time. An easy example is ancient Egyptian sculpture, which shows many of the same aspects of style over nearly two millennia.

Personal style. An individual artist's distinctive look, a fusion of elements that is as distinctive as handwriting.

Content

Content may be thought of as what arises in you when you behold the work of art. The word **content** refers to *meaning* in the sense of "What does this mean?" It is the sum of the subject matter (iconography), the formal treatment of it (form), the composition, style, the materials and techniques the artist used to make it, and many less quantifiable qualities and circumstances. Some of the latter are the artist's *intention,* which is not always obvious, and the *historical and social context* of the

ATTRIBUTION

Classifying a work of art as belonging to a *period, region, school,* or *individual artist* is called **attribution**. (Even works that are signed and dated need attribution, in case the signature and date are not authentic.) On what do art historians base their attributions? They look carefully at physical materials, style, and iconographic features. When exactitude is not possible, art historians use phrases like these:

autograph. A work is *autograph* when there is no doubt that the entire work is by the artist named.

attributed to. This term implies that the work is not proven to be by the artist named—when a work bears the artist's signature, but there is doubt about the signature's authenticity based on style or on other measures of attribution, including evidence that assistants executed major parts. It is also used when there is no signature or documentary evidence as to a work's provenance, but the work is convincingly like an artist's known works.

ascribed to. Used to indicate slightly more doubt about an attribution than "attributed to." In can also suggest an old attribution, perhaps in doubt, but used for the sake of convenience.

school of. The first of two usages is when a work shows stylistic traits in common with an established cluster of artists working in a similar style (so-called school), such as School of Delft. The second use is with an unattributed work in the style of the master named, for example, school of Caravaggio.

workshop of/studio of. Attributes the work to someone—not the master—who worked in the master's established workshop or studio.

circle of/style of. A catchall attribution for works by unknown artists working in the style of the artist or school named.

follower of/in the manner of. Indicates a date later than the person or school named.

after. When you see *after,* you are looking at what is thought to be a copy or a derivative work.

work, which can be only imperfectly known even with much study. Finally, content is shaped for each beholder by his or her experience, interests, knowledge, and aesthetic responses. The content—the meaning—of Brueghel's *The Peasant Wedding*, figure 31, will be very different for, say, a Northern European farmer than for an American woman with an advanced degree in European history. The farmer may delight in recognizing generically familiar faces and foods because he or she has grown up with descendents of the peasants in the picture and may be interested in the details that show how different life is today than it was more than five hundred years ago. In contrast, the American scholar of European history is likely to have specialized interests, such as the role of women in European history. In that case, she may study Brueghel's treatment of the bride, looking for clues about the societal status of peasant women at the time of marriage. The scholar is more likely to be aware that Brueghel created his image, not as a "wedding photographer," but with a point of view of his own.

What Is Art Made Of, and How?

Artworks and architecture are physical objects created with various means (materials) and in different ways (techniques).

This section deals with materials and techniques, and once again we benefit from categories. Traditionally, fine arts are grouped according to whether they are two-dimensional or three-dimensional.

The **two-dimensional arts** include

> drawing
> painting
> the graphic arts
> photography

The traditional **three-dimensional arts** are

> sculpture
> architecture

Other media not categorized by dimensionality are now recognized as art. These include

> stained glass
> weavings and textile arts
> objects of glass, metalwork, and ceramic

Contemporary artworks defy all the old expectations and categorizations of art and include

> installations
> performance pieces and happenings
> video art, computer art, and multimedia pieces

Drawing

Usually made on paper, drawings are compositions of line and shade executed with pencil, ink, or crayon, sometimes with color added.

Drawing as a broad category includes

> **sketches**. quick visual notes
> **studies**. carefully worked-out drawings of details or whole compositions, made as study exercises or in preparation for other works, usually paintings
> **independent drawings**. complete, finished artworks in themselves
> **cartoons**. full-scale drawings (and sometimes paintings) made for transferring a design to a large wall painting or easel painting

Most ink and pencil drawings are *linear*. When a soft material such as charcoal is used, the drawing is more *painterly*, which means that forms are defined more by tonal mass than by line. Figure 14, a charcoal drawing by Käthe Kollwitz, is an example of a painterly drawing.

NOTE: Crayon *is a generic term that includes chalk, Conté crayon, pastel, wax, and charcoal—greasy substances made in stick form for the purpose of drawing.*

Painting

The simplest definition of painting is the application of color—**pigment** or paint—to a **support**, ranging from bare stone or plastered walls to canvas, board, parchment or vellum, paper, papyrus, cloth scrolls and banners, ceramic vases, furniture—almost any surface that bears decoration.

The main categories of painting you will encounter are

> **wall painting**. pigment or paint applied directly to a surface, as we find in Neolithic caves, and on walls, ceilings, and other interior and exterior surfaces of buildings that have a suitable layer of support.
> **mural painting**. decorative painting of walls, ceilings, and vaults. Murals may be painted on walls or on canvas that is applied to surfaces. What distinguishes mural painting from wall painting is that murals are conceived and executed for particular surfaces of specific buildings, with decorative effect their primary intent. Figure 32, showing part of a room in a private house in Pompeii, Italy, is a mural painting done in fresco technique.
> **panel painting**. painting on wood boards, usually joined together, planed smooth, and covered with a base coat compatible with the kind of paint being applied. Until the Renaissance, wall painting was the dominant form of painting. With more secular patronage, smaller, more portable paintings gained favor.
> **easel painting**. a dated but useful term for paintings of a size that could have been supported on an upright stand, called an easel, while the artist was working. These are mostly wood panels or canvases that have been stretched tight over a wood frame.
> **illumination**. the decoration of parchment or vellum manuscripts, principally in Western medieval times, with colored initial letters, decorative motifs in the margins, and paintings ranging in size from tiny to full page. *Parchment* is the skin of sheep or goats that has been processed to produce a smooth, light-colored surface. *Vellum* is made from the skin of calves. Its surface is finer than that of parchment, and it is a more prized material. Most illuminations were painted with tempera, and many were further embellished with gold.

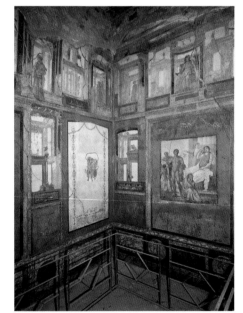

32. Mural paintings in the Roman Fourth Style, Ixion Room, House of the Vettii, Pompei, Italy. 70–79 C.E. © Canali Photobank, Milan.

PROCESS

The process of painting is essentially unchanged from its Neolithic beginnings to the present. Powdered substances, pigments, are mixed with a **binder**, or **vehicle**, that holds the pigment particles together and helps the mixture adhere to the support.

The oldest paintings still in existence were painted nearly 30,000 years ago on the walls of caves in southern Europe, where pigment was applied directly to the stone. Most supports, however, need to be **primed** with at least one base coat of a paintlike substance called a **ground**. Traditionally, paint is applied with brushes or painting knives. Some paints are inherently opaque: encaustic, fresco, tempera, oil, and acrylic. Others, such as watercolor, are translucent. When diluted watercolor is applied to a broad area, such as a sky, the area, as well as the technique, is called **wash**.

MATERIAL AND TECHNIQUE

Encaustic. One of the oldest and most durable of painting techniques, *encaustic* painting was practiced in ancient Greece and specialized late Egyptian cultures. Encaustic combines pigment and a hot wax binder, which demands rapid application—before the wax hardens. Encaustic is rarely used today.

Fresco. A very old technique of wall painting, *fresco* is powdered pigment mixed with water that is applied to and absorbed into a layer of lime plaster (the *intonaco*). The fresco painting becomes part of the wall and lasts as long as the layer of plaster holds. In true fresco, called *buon fresco* (*fresco* means "fresh"), the pigments are applied section by section to the still-moist *intonaco,* which the artist must paint before the plaster dries. The tones of fresco painting tend toward chalkiness because the plaster adds white to the already water-thinned pigments.

Fresco secco (dry fresco) is an inferior technique, in which tempera paint is applied to a wall that has been merely moistened. When moisture builds up between the wall and its layer of paint, the paint flakes or peels off.

Tempera. To make *tempera,* the artist makes a paste of dry pigment and water, then makes an emulsion by adding fresh egg yolk in equal amount. Tempera is applied to a smooth ground, usually wood panel, coated with a thin layer of *gesso.* (Gesso is a mixture of chalk or plaster and an animal glue; it can produce a very smooth surface.) Tempera lost favor after the introduction of oil paint in the fifteenth century, but was the chief painting medium between the twelfth century and the Renaissance.

Oil. Finely ground pigment is mixed with a vegetable oil—linseed, walnut, or poppy—to make the opaque medium that has dominated Western painting since the Renaissance. (Most easel paintings are oil on canvas.) The great advantages of oil paint over tempera are the depth and richness of its color, the artist's ability to mix colors on the palette or painting to derive new colors, the fact that it can be painted over, and its exceptional durability. When oil paint is laid on so thickly that the strokes of the brush or palette knife are visibly raised off the surface, the effect is called *impasto.*

Watercolor. Pigments suspended in a solution of water and *gum arabic* (a hardened but water-soluble sap obtained from trees in the genus *Acacia*) produce a watery, translucent medium that we call watercolor. The ground is white or light-colored paper, which the artist dampens before brushing on the paint. To get the soft effect so characteristic of watercolor, the artist dilutes the paint and applies it in broad washes. Fibers in the paper absorb and "feather" the paint's edges. White and light tones are not paint, but the white paper ground showing through. Ancient Egyptians painted with watercolor, but it was only in the nineteenth century that artists took it seriously as a major medium.

Enamel. As a painting medium, the term *enamel* has three meanings. One refers to a vitreous porcelain or ceramic glaze that is applied to pottery or metal and fused at high temperatures. The result is a hard, usually smooth and shiny finish. Second is enamel paint, which is pigments borne in a *resin varnish* that can be either air dried or baked on. (Resin varnish is a solution of a solvent and either natural

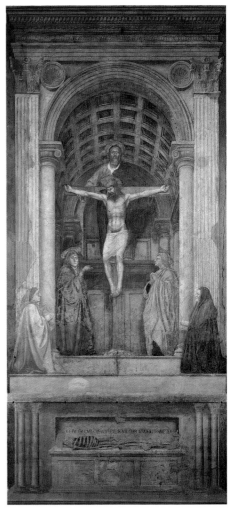

33. Masaccio. *Holy Trinity,* fresco in Santa Maria Novella, Florence, Italy. c. 1428. © Canali Photobank, Milan.

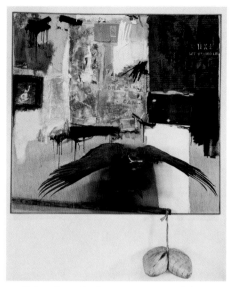

34. Robert Rauschenberg. *Canyon.* 1959. Oil, pencil, fabric, metal, cardboard box, printed paper, printed reproductions, photograph, wood, paint, and mirror on canvas, with stuffed bald eagle, string, and pillow. Sonnabend Collection. Copyright © Robert Rauschenberg/Licensed by VAGA, New York.

Rauschenberg's work layers all manner of two-dimensional and three-dimensional materials and objects—some protruding far from the support—in highly textured, evocative, and provocative works that have expanded the definition of painting.

or synthetic resin; natural resins are pitchlike secretions of various trees, while synthetic resins are synthetic, chemically produced organic compounds with characteristics of natural resins.) The third meaning is the translucent glaze made of ground glass, colored with metal oxides, used to paint stained glass (see below).

Gouache. Like watercolor, *gouache* is a water-soluble paint, but it is an opaque medium because chalk or a chalklike filler is added to the solution of pigment, gum arabic, and water.

Acrylic. Introduced in 1936, *acrylic paint* began to be widely used in the 1950s, when researchers discovered a method for mixing synthetic resins with water. Strictly speaking, the term *acrylic* applies to synthetic polymers that contain acrylic acid. In practice, *acrylic* is loosely used for various synthetics-based paints that substitute for oil-based ones. Acrylics dry quickly and are exceptionally durable.

Mixed media. A term used to describe a work of art that combines various materials and techniques, *mixed media* is a comparatively recent development that spans painting, sculpture, and many new visual and pictorial idioms.

NOTE: *The terms* mixed media *and* multimedia *are easy to confuse. Multimedia is an art form that combines film, video, recorded sound, and projected images, sometimes with the artist or artists performing in live appearances.*

Mosaic. A very old, extremely durable technique for making pictures and designs, *mosaic* uses small, cubelike pieces of very hard materials such as stone, marble, shell, opaque glass, and tile, called *tessera* (pl., *tesserae*), that are set in grout or resin (mastic). Mosaics are found on walls, ceilings, floors (as pavement), and on smaller objects. Like early stained glass, mosaic is one of the paintless media of painting.

Stained glass. The reason *stained glass* is recognized as painting is that artists make color pictures in this medium. To be visible, a light source, usually daylight, is needed behind it. Until the sixteenth century, images were created from small pieces of unpainted, shaped colored glass fitted into deeply grooved lead strips that "drew" outlines of the forms. When translucent glazes of vitreous (fusible) enamel were developed in the Renaissance, artists could paint color images onto clear or colored glass. The design is worked out on a chalk-covered board before the lead and glass are assembled over the design.

Graphic arts

The term **graphic arts**, as one of the two-dimensional fine arts, refers to the various processes that are used to create **prints**. Prints can be defined as images made in ink by transfer from the surface on which they were drawn—the printing surface—to another, more porous surface, most often paper. Printing surfaces traditionally have been wood, metal plates, and stone. Because the printing surface can be re-inked, prints are *repeatable*, although they are never absolutely identical. And because the transfer occurs surface-to-surface, the printed image is the *reverse* of what is drawn on the printing surface.

Prints are either manual prints or process prints. **Manual prints** are those in which the artist creates the image directly on the printing surface. **Process prints**, which appeared first in the mid-nineteenth century and dominate today's printing technologies, allow artists to create images on a surface of their choosing—usually paper—and let technologies of various kinds do the transferal to the printing surface.

Every print is made by one of four different methods: relief, intaglio, planographic, or serigraphy.

Relief. In *relief* prints, the image prints from ink *applied to a raised surface.* Whatever is not supposed to appear has to be carved away, or subtracted, from the printing block, whether wood or metal or stone. Relief is the oldest print method. The earliest surviving relief print, carved on wood blocks, is a Chinese Buddhist

text dated 868 C.E. The earliest printed books in the West, as well as individual letter forms, called movable type, are from the 1450s and are also relief printing from wood. The earliest relief prints appeared in Europe fifty years earlier, about 1400.

Intaglio. In intaglio prints, the image prints from ink that has been *pressed into grooves* on the printing surface, the opposite of the relief principle. The word *intaglio* is Italian for "incising" or "engraving," which is how the artist makes the grooves in the printing surface. Intaglio allows the artist to draw directly onto the printing surface (knowing that the print itself will be the reverse of what is drawn), create much finer lines than with relief, and transmit a far more personal quality of line. Intaglio was developed as a printing method in Europe, probably around 1430. The two most important intaglio media are *engraving* and *etching*.

Planographic printing. Also called *surface printing,* planographic printing relies on the incompatibility of grease and water. **Lithography** is the most common traditional planographic technique. The artist draws with a greasy drawing implement, a *crayon,* on the printing surface, a smooth but porous *lithographic stone.* The surface is then treated with chemicals that make the greased areas receptive to ink and the ungreased areas hold water on the surface. When ink is rolled onto the dampened surface, it clings to the greased areas, where there is little or no water. A sheet of paper is laid on the inked stone, and the whole "package" is pushed under a padded scraper bar to force the ink's transfer from stone to paper. Lithography's invention is credited to Aloys Senefelder and dates from the 1790s.

Serigraphy. Known also as *silkscreen* and *screen printing,* serigraphy is a stencil technique in which ink is forced through a taut fabric mesh, traditionally silk and now often nylon or polyester, that the serigrapher has prepared by blocking and opening areas before inking.

35. Albrecht Dürer. *Last Supper.* 1523. Woodcut. British Museum, London. Copyright © British Museum, London.

The German Renaissance painter and graphic artist was a brilliant technician in both woodcut and engraving. Some of Dürer's many workshop assistants probably did the tedious and extremely fine cutting, using their master's designs.

36. Martin Schongauer. *Anthony Tormented by Demons.* c. 1480–90. Engraving. Metropolitan Museum of Art, New York. Photo copyright © 1980 Metropolitan Museum of Art, New York. All rights reseved.

Schongauer was an early master of engraving. This great print dates a full generation before Dürer's woodcut, Last Supper.

37. Henri de Toulouse-Lautrec. *Seated Clowness,* from *Elles,* a series. 1896. Lithograph printed in five colors. Metropolitan Museum of Art, New York The Alfred Stieglitz Collection, 1949 (49.55.50). Photograph copyright © 1984 Metropolitan Museum of Art., New York. All rights reseved.

Toulouse-Lautrec combined a spray technique with his superb crayon work for this technically sophisticated lithograph. Because only one color (including black) can be printed at a time, the sheet has to be in perfect alignment (registration) as it is placed on the stone; otherwise the print will appear blurry.

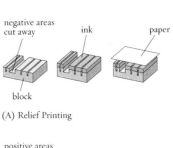

(A) Relief Printing

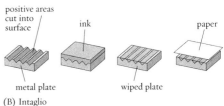

(B) Intaglio

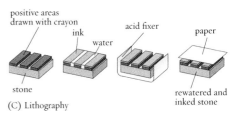

(C) Lithography

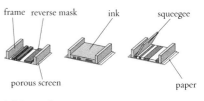

(D) Serigraphy

38. Steps in preparing the printing surface, inking the block, and transferring ink to paper for the four main printmaking technologies.

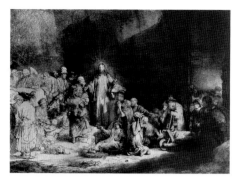

39. Rembrandt van Rijn. *Christ with the Sick around Him, Receiving the Children* (Hundred Guilder Print). c. 1649. Etching, with engraving and drypoint. Pierpont Morgan Library, New York. © The Pierpont Morgan Library/Art Resource, New York.

Rembrandt was the ultimate master of the etching medium. He experimented with techniques—here combining etching with drypoint and engraving—and with different papers. The medium is perfectly suited to Rembrandt's direct, highly personal style.

retina (photosensitive surface)

film (photosensitive surface)

40. Optics of the camera and the human eye

Relief techniques

Altogether there are at least fifteen relief print techniques. The ones you encounter in museums and books most often are

> **woodcut**. The plank side (with the grain) of the wood block is carved away.

> **wood engraving**. The end grain (against the grain) of a very hard wood is carved away using an engraver's tool called a *graver*.

> NOTE: *If the ink sits on a raised surface, it's relief. The confusing use of* engraving *refers to the tool used for cutting.*

> **metal relief**. An alloy of soft metal is cut with a metal engraver's tool called a *burin*.

Intaglio techniques

> **metal engraving**. The engraver cuts (*incises*) the design with a graver, in reverse of course, on a sheet of copper or steel. Metal engravings are characterized by crisp line and fine detail. Schongauer's engraving *Anthony Tormented by Demons*, figure 36, is an example of what the medium is capable of.

> **etching**. A metal plate, usually copper or zinc, is coated with a waxy overlayer (*ground*). The etcher draws on the ground with an *etching needle*, exposing the metal in the process. The plate is then dipped in a bath of acid that bites, or etches, the lines in the metal so that they will hold ink for printing. Compared to engraving, etching is a delicate technique. The lines are softer and finer, and because the channels for ink are shallower, they break down sooner.

> **aquatint**. Allied to etching, aquatint employs an etching plate covered with a fine layer of resin. When the plate is dipped in the acid bath, tiny pits form on the surface of the plate, producing a fine-grained tone when printed. Dark and light tones are manipulated by applying varnish over the resin. The more varnish, the lighter the tone.

> **drypoint**. Drypoint is an intaglio technique used often in connection with etchings, where it is used to add delicate touches or light shading. The artist draws on an uncoated plate with a sharp point (instead of a graver, which the engraver uses). The tool throws up a rough edge, a *burr*, which produces a velvety line when inked and printed.

> **mezzotint**. Light and dark tones are difficult to achieve with line. Mezzotint, popular in the eighteenth and nineteenth centuries, gets its effects by using a toothed tool called a *rocker* to cover the metal plate with a layer of small hole-like depressions. Light tones are produced by scraping off the burr before inking; middle tones are partly scraped; and dark areas are untouched.

Photography

Photography was invented, or discovered, in 1829. It took more than a hundred years before it was recognized as one of the arts, in spite of the fact that photography and its descendant, **cinematography**, have influenced popular culture more than any other art form.

In elemental terms, photography (except for digital photography) works as follows. The photographer focuses on a subject. An image of what the camera sees is projected through a **lens** to a **photosensitive emulsion** covering the **film** at the back of the camera. The film is developed in chemicals, producing a **negative**, and the negative is used to print the image on photographic paper. Figure 40 shows the similarity of the optics of the camera and the human eye.

Sculpture is art in three dimensions. A sculptor imagines the finished form very differently from the way a painter or graphic artist imagines a painting or print. And the creative act is much more physical for sculptors than for most artists who work in two dimensions. Sculpture is either *additive, reductive,* or *assembled.* It can be *freestanding, attached,* or *relief.*

Additive. Forms built up, or *modeled,* from formless lumps of malleable materials, among them terra cotta and other clays, wax, and plaster.

Reductive. Forms revealed by removing material. Wood, stone and marble, ivory, bone, and gemstones are the most-carved materials. Plaster, clay, and wax are materials that can be worked both additively and reductively.

Assembled. Sculpture constructed of elements—sometimes made of different materials—that combine in an integrated whole. The parts are welded or attached in some way.

Freestanding. Sculpture that is viewable all the way around and is often called *sculpture-in-the-round. Old Market Woman,* figure 41, is a freestanding marble sculpture from a late period of ancient Greek art, called the Hellenistic period.

Attached. Sculpture that is partly joined to, or is part of, a wall or other architectural member. Figure 42 shows the carved figures of the *Visitation* to Mary by her cousin Elizabeth, which appear to stand well out from the columns, but are actually attached. Architectural sculpture—sculpture conceived in the context of a building—is mostly attached or relief sculpture.

The four major traditional sculpture techniques are

> relief
> carving
> modeling
> casting

Relief. Carved or cast sculpture that projects from a ground. Depending on how far the image projects from the ground, reliefs are categorized as *high relief* or *low relief.* One of the greatest examples of low relief carving is the nearly 2,500-year-old *Dying Lioness* in figure 43, where the play of light over the surface reveals just how subtle low relief can be in the heaving flanks and agonized face of the mortally wounded beast.

Carving, modeling, and *casting* are the three most important traditional sculpture techniques. Twentieth-century materials and techniques include *assemblage, readymades, kinetic sculpture, light sculpture, mixed media, earthworks,* and *environmental sculpture.*

Carving. A reductive technique, carving is suited to hard materials such as stone and marble, wood, and ivory. Because the sculptor begins with a block of raw material, he or she must have a very clear idea of what the sculpture is supposed to look like and a strong spatial imagination. Some sculptors begin with a *maquette,* a small model of the sculpture they intend to carve. Carving is done with *mallets* and *chisels*—the sizes of which depend on the scale of the sculpture and the nature of the material.

Modeling. An additive technique, modeling is more forgiving than carving in the sense that the sculptor can rework the material over and over until satisfied with the form.

Casting and lost-wax casting. In the simplest of terms, casting is pouring a material that is in a liquid state into a mold, letting the poured material harden, then releasing the finished piece from the mold. The materials most often cast are bronze, an alloy of copper and tin, and brass, an alloy of copper and zinc.

Lost-wax casting is the technique traditionally used to cast sculpture. Probably the most efficient way to grasp the process of lost-wax casting is to remember that it uses two models and two molds. The first model is what the finished metal sculpture will look like. Shaped of malleable material such as clay or wax, it is encased in

41. *Old Market Woman.* c.150–100 B.C E. Marble. The Metropolitan Museum of Art, New York.

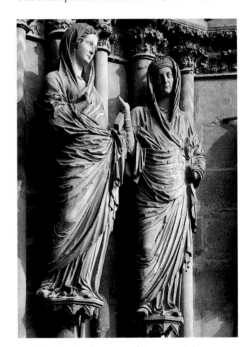

42. *Visitation,* jamb statues of the central doorway, west facade, Reims Cathedral, Reims, France, c. 1230. © photo Jean Mazenod, L'art gothique, Éditions Citadelles & Mazenod, Paris.

43. *Dying Lioness* (Assyrian), detail of a relief from the palace of Ashurbanipal, Ninevah (modern Kuyunjik), Iraq. c. 645–640 B.C.E. British Museum, London. Hirmer Fotoarchiv, Munich.

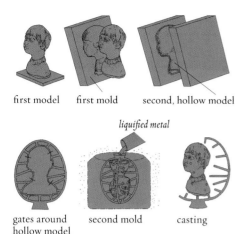

first model first mold second, hollow model

liquified metal

gates around second mold casting
hollow model

44. Steps in the lost-wax process

wet plaster or a gelatin substance that can be sliced open once it has set. It contains the impression of the original model. The mold is then lined with molten wax, either by brushing it on both surfaces of the opened-up mold, or pouring wax into the mold in which a solid core has been suspended. After the wax hardens and the mold is removed, the wax model (the second model) serves as a hollow replica of the original clay model. The hollow wax model is placed upside-down in a container, with wax rods (*gates*) attached all around the model and to a pouring spout. A mixture of silica, clay, and plaster is poured into the container and into the wax model—filling any place where there is no wax. Turned right-side-up, and under high firing temperatures, the wax melts and runs out (*lost wax*). The silica mixture hardens to form the second mold, the mold that receives the molten metal. The mold is turned upside-down again, and the liquefied metal is poured. As the metal flows in, air is pushed out the gates that were formed by the wax rods. The second mold is removed, revealing the casting, rods and all. The rods are cut off, and the surface of the casting is finished according to the sculptor's vision for it. Figure 44 helps to visualize the process.

Architecture

Architecture is a parallel art to painting, the graphic arts, and sculpture. Works of architecture can possess the highest degrees of *aesthetic* expression, and the history of architecture is studied along with the other fine arts. But architecture is, above all, a practical and utilitarian art. It must be concerned with matters of engineering and is closely bound to technology and its material innovations.

SPACE-SPANNING CONSTRUCTION

When humans moved out of caves and had to construct roofs over their heads, they had to cope with the downward pull of gravity. Over time, the following construction methods have been devised to span space:

> post-and-lintel
> arch and vault
> dome
> cantilever
> steel frame
> balloon frame

CLASSICAL ORDERS

The ancient Greeks, beginning before 600 B.C.E., developed what is known as **architectural orders**. An *order* is a system of proportions. Over time, the Greeks developed three different orders for their temples and other public buildings: *Doric, Ionic,* and *Corinthian,* in that sequence. All three classical orders survive to the present time, though often greatly distorted and misunderstood. Almost every town of any size in the United States has at least one building—a bank or a church—that is based in classical Greek architecture and its orders.

The components of all Greek orders are the **column** and the **entablature**. Above the entablature is the **pediment**, the triangle formed by the top the entablature and the sloped roof. Look closely at figure 45.

The column has these parts:

> capital
> shaft
> base

45. Doric, Ionic, and Corinthian orders

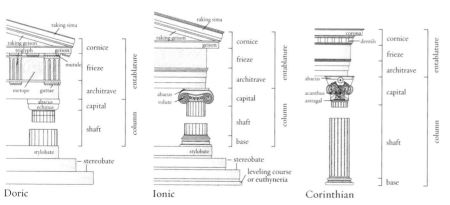

Doric

Ionic

Corinthian

26

SPACE-SPANNING CONSTRUCTION METHODS

From the simplest to the most complex, all methods of covering open space transfer weight (*load*) to the ground. If the engineering is faulty—if the span is too great for the strength or flexibility of the spanning device—it will collapse.

The oldest and simplest method is **post-and-lintel** construction. The uprights (posts) provide resistance to gravity; the horizontal spanning element (lintel) transfers its weight to the grounds by means of the posts. Another early device, the **corbeled arch**, transfers weight to the surrounding wall, and thus downward, in small increments of overlapping stones or bricks. The **round arch**, fully developed by the Romans, and the **pointed arch**, which came later, were the basis of **vaults** capable of covering large areas. **Barrel (tunnel) vaults** are essentially a series of round arches. When arches, either round or pointed, are constructed on four sides of a space to be covered then joined over the top to meet at the center, they form **groin vaults**. **Ribs** at the junctures of the vaulting help transfer weight to the corners and downward.

Pointed-arch construction enables the space beneath the vaulting, called the **bay**, to be rectangular. Round-arch construction favors square bays.

Dome construction sends weight evenly down to the rim of the dome, where it rests on architectural members that continue to transfer the weight downward. The **cantilever**, in which the horizontal member can extend well beyond the uprights, was made practical by the discovery that iron rods embedded in concrete horizontals increase the strength and flexibility of the horizontal member sufficiently to enable a wider span and longer overhang. **Steel-frame** construction dominates commercial architecture today. It utilizes steel's properties of flexibility and great strength to bear enormous weight loads. **Balloon-frame** construction, used in residential and small commercial buildings, is essentially an elaborated post-and-lintel construction method that exploits the lightweight and flexible properties of wood.

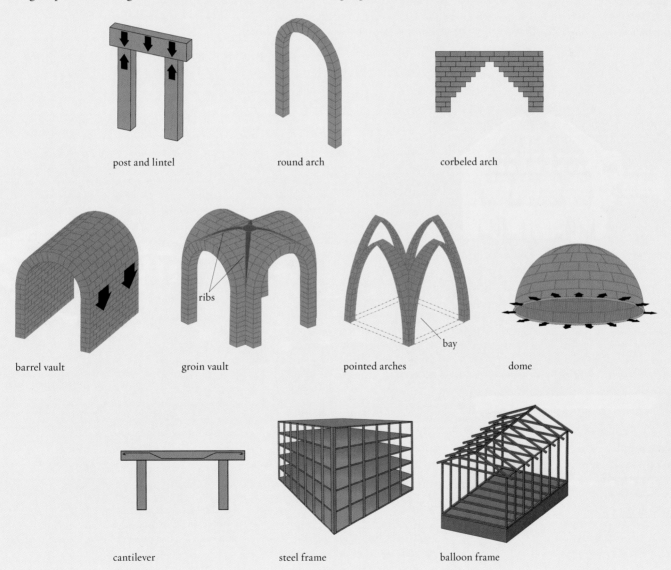

post and lintel

round arch

corbeled arch

barrel vault

groin vault

ribs

pointed arches

bay

dome

cantilever

steel frame

balloon frame

46. Plan

A ground plan shows a building's masses and spaces as if the structure had been cut through just above ground level. In the case of multistoried buildings, there can be a floor plan for each story that shows the layout of rooms and spaces.

The entablature in the Doric order treats the frieze differently from the Ionic and Corinthian orders, but the elements are the same:

> architrave
> frieze
> cornice

ARCHITECTURAL NOTATION

Visualizing architecture, the ultimate three-dimensional art, in two dimensions is done in several ways. The three most conventional means you will encounter in books are the **plan**, **section**, and **elevation**. Other forms of two-dimensional notation are the bird's-eye view, the *cutaway, isometric projection,* and *axonometric projection.* Computer-generated conceptual models of architecture, both built and unbuilt, including animated walk-throughs and multilayered visualizations, are revolutionizing the design process and our ability to virtually experience architecture.

 Cutaway drawings show a building as if looking down on it from above at an oblique angle, but with the roof and some of the walls opened up to reveal some of the interior elements, such as columns.

47. Sections

Sections reveal the structural elements from a vertical perspective, as if sliced from top to bottom. The more sections one sees of the same building, the easier it is to understand and visualize the whole thing.

48. Elevation

The exterior faces (facades) of buildings are shown in elevations.

49. Cutaway view

What Are We Looking For?

In studying works of art, the questions (besides how and why) are what, when, where, and who.

Art history is a field that offers endless opportunities for sleuthing. Art historians want to know when and where something was made, exactly where and how it was originally seen, what purpose it served, and who was involved in its creation. We have two sorts of information: *external*, documentary evidence and the object itself, which is *primary* evidence.

Civic records such as those for births and deaths, marriages and divorces, and personal and property transactions are sources of information. Inventories of personal property, legal and court records, church baptismal and other records, and membership lists of societies, guilds, and the like may contain information about an artist and certain works of art. Auction records are another source of information.

Documentary evidence

The object carries the physical, material evidence. You have to be able to handle the artwork to examine the following:

Evidence of the object

> material(s) from which it is made
> technique for working the material(s)
> evidence of a signature or other identifying mark

Materials can be very specific to a geographical region, either naturally or by preference. An experienced art historian knows that a sculpture carved of linden wood is likely to be from northern Europe. In the past, precious materials were traded, so trade routes are taken into account in determining an artwork's origin. **Techniques** are solid clues, too. The way paint is stroked on a painting, the method of joining pieces in a wood sculpture, or the form of the chisel marks on carved stone are just three of the endless kinds of physical evidence. The most obvious evidence is a **signature or other identifying mark**. But signatures can be faked or added later, so close comparison with validated signatures is needed to authenticate a work.

STYLE

Style is ultimately the most persuasive evidence of an artwork's origin, and stylistic analysis usually can be done using photographs and reproductions. (The concept of style was introduced on page 18.) The art historian narrows the stylistic identification from general to specific. The most general stylistic descriptors are

> naturalistic (or realistic)
> expressionistic
> nonobjective (or nonrepresentational)

Naturalistic, sometimes used interchangeably with *realistic*, describes the representation of objects—especially those in nature and the human form—with the least degree of distortion or subjective interpretation. Figure 43, the Assyrian relief of the wounded lioness, is a clear example of naturalism. Some writers on art make a distinction between naturalistic and **realistic**, using *realistic* to mean a style that imitates visible reality as closely as possible. The individual objects in figure 22, *Marilyn*, by

Audrey Flack, are painted realistically. Note that the word *realism* is often confused with *Realism* (with a capital *R*). The latter is a movement that arose in France in the mid-nineteenth century.

Expressionistic styles convey intensified emotional states and dramatic events by distortion of natural form, color, scale, space, or a combination of these. Expressionistic styles favor asymmetrical compositions and often rely on diagonal axes. They are intended to arouse subjective responses. *Old Market Woman*, figure 41, was sculpted more than two millennia ago, but its expressionistic qualities strike us as comparatively modern. Her desperate, headlong lunge gets our attention and tempts us to wonder why she looks so worried. Expressionism (with a capital *E*) is also the name of an important modernist movement.

Nonobjective and **nonrepresentational** art does not picture objects that are recognizable from nature or experience. It relies instead on formal elements to carry its message. Jackson Pollock's *One (Number 31, 1950)*, illustrated on page 11, is nonobjective. It is also purely *abstract* in not representing or imitating any visible object, but is a composition of writhing lines. And it is *expressionistic* in the active, almost feverish quality of the lines. (Not surprisingly, this painting is an icon of the mid-twentieth-century movement called Abstract Expressionism.)

> NOTE: *In a literal sense, all art is abstract, because there is no way for an artwork to be the object it represents. However, it is not hard to see degrees of abstraction. The self-portrait in figure 14 is less abstracted than* The Cry, *figure 6. But in both works, the artists abstracted their subject matter.*

The identification process gets more specific as it progresses from period style and national or regional style to personal style, which were mentioned previously on page 18. Period styles can be as broad as, say, Italian Renaissance or as specific as Early Tuscan Renaissance. Since the nineteenth century, with the galloping proliferation of movements and directions, styles are identified and codified at an ever-faster pace.

Where Do You Find Art?

And once you find it, what are the most favorable conditions for experiencing it?

When art is in its original location, it is **in situ** (Latin for "in position.") In situ arts include

> paintings and carvings on exterior or interiors walls, ceilings, or other surfaces of public buildings and private dwellings, royal residences, religious structures—including caves
> structures and contents of preserved and restored sites
> places of worship, where the artworks still have a religious purpose
> regional and local historical sites
> public monuments made for a designated site

Not every site is open to the public, and some are open only at certain times. The Internet is now the best source of current visiting information.
 Art not in its original context can be found in

> museums, which collect, keep and protect, research, and display art
> commercial art galleries and dealers, which offer art for sale and do not charge admission

> private collections, only some of which are open to the public
> regional and local historical museums
> auction houses, where originals may be viewed in the brief time between passing from one owner to another

Most *museums* around the world charge entrance fees, either fixed or voluntary. Students with valid identification usually pay less than the standard adult fee, and many museums have one day or evening a week when no admission is charged.

 Art galleries and *art dealers* vary in the degree to which they make the public feel at home, but most would rather have visitors than not. Private collections are usually just that: private. *Auction* houses have preview dates for viewing without obligation to bid or buy. Information about upcoming auctions is easily accessible in newspapers and on the Internet.

 Art out of context is the only way we can see most of the world's greatest art. While the museum experience allows us to appreciate the object in a formal and physical sense and gives us information about the artists, the patrons, and some circumstances of its creation in the form of labels and wall text, experiencing art in well-lighted, temperature-controlled rooms is very different from the original encounter. Good art history helps us re-create the original experience.

Studying Art and Learning about Art

Art can be approached by many paths.

Studying art or architecture or design in order to be an artist, architect, or designer is very different from learning about art, which is what happens in *art appreciation* and *art history* courses. Students in the studio arts inevitably look for and see art from the perspective of making it, regardless of the approach of the course.

Art appreciation can be thought of as a pedagogical approach. Courses in art appreciation are intended to cultivate skills for close observation of art and to open one up to art's many pleasures. Course content varies, depending on the interests and preparation of the instructor. Some have a small historical component, while others are heavily weighted toward history.

 Art history is an academic discipline that studies visual culture through the history of civilization, examining art's role in different societies and interpreting what visual/spatial expressions say about a society at any one time. Art history was first recognized as an academic field in 1844, which makes it a comparatively recent discipline. Graduate programs in art history grant degrees from Master of Arts (MA) through the Ph.D. Art historians become college and university teachers, writers and editors, independent researchers and scholars, art critics, museum and gallery curators and administrators, and arts administrators, among other things.

Art appreciation and art history

Introductory art history courses present art as it was created over time, usually as a chronological narrative but sometimes according to themes, such as the human figure in art. Art history has developed a number of different methodologies. We have already encountered *formal analysis* and *contextualism*. In order of their emergence, here

Art history methodologies

are the most significant methodologies.

Biography and autobiography looks at works of art in relation to artists' lives and personalities. Although artists are mentioned in Egyptian, Greek, and Roman writings, only since the Renaissance has artistic biography and autobiography been a constant interest. Today biography is a relatively uncommon methodology.

Formalism stresses the role of form over anything else in analyzing and evaluating works of art. (Formal analysis and formal elements are discussed on pages 11–19.) In its purest application—rarely practiced—formalism discounts the influence of both the artist and the culture in which a work of art was created. Formalism lends itself to analysis of **style**, and for decades around the turn of the twentieth century, formal and stylistic analysis were the favored methodologies.

Iconography as a methodology stresses the meaning of the subject matter. (See page 11.) In contrast to formalism, iconographic analysis is more concerned with content than with form. The methodology came of age in the 1940s and 1950s.

Contextualism looks at art as an expression of prevailing conditions (contexts) at the time and place of its creation: political, religious, social, and cultural. Contextualism has been growing in favor since the 1930s and has been the dominant methodology for more than thirty years. Two significant specialized contextual methodologies are **Marxist**, *which approaches art as a response to prevailing economic and social forces and influences,* and feminist. Class and patronage are major areas of inquiry in Marxist art history, which arose in the 1930s. **Feminist** *art history approaches the study of art with the premise that gender must be taken into account for a true understanding of art's creation, content, and value.* Specifically, feminist art historians seek to explain why, until the twentieth century, very few women became professional artists and what that says about the context for evaluating art.

Semiotics *(or semiology) in its several art historical manifestations is based in the belief that all human efforts to communicate—whether verbal or symbolic—are based in signs and that these signs have meaning beyond what is readily apparent.* Semiotics had been around awhile, particularly in the study of language and literature, but was first applied to the visual arts in the late nineteenth century. Structuralism, Post-Structuralism, and Deconstruction are three main semiotic methodologies that have found a following among art historians. All are conceptual, rather than object-based, methodologies. **Structuralism** *seeks (or sought) to identify universal mental patterns, or structures, that function in kinship and in larger social structures and unconsciously motivate human behavior.* Artist and context are not centrally relevant in Structuralist methodology, which gave way to Post-Structuralism around 1968. **Post-Structuralism**, *while continuing to deal with signs, holds that signs can be neither universal nor structured into closed systems. Deconstruction is a Post-Structuralist approach that asserts that the meanings of signs cannot be fixed but vary according to context.*

Psychoanalysis *as a methodology of art history focuses on the unconscious significance of works of art to the artists who created them, to the beholders who view the artworks, and even to the contexts.* Much conventional psychoanalysis explores the symbolism of images, of course, but psychoanalytic methodology incorporates most of the other approaches as well: iconographic, autobiographical and psychobiographical, Marxist, feminist, and semiotic.

Increasingly, art history is practiced and taught using a combination of methodologies, and this deepens and enriches its excitement and pleasures.